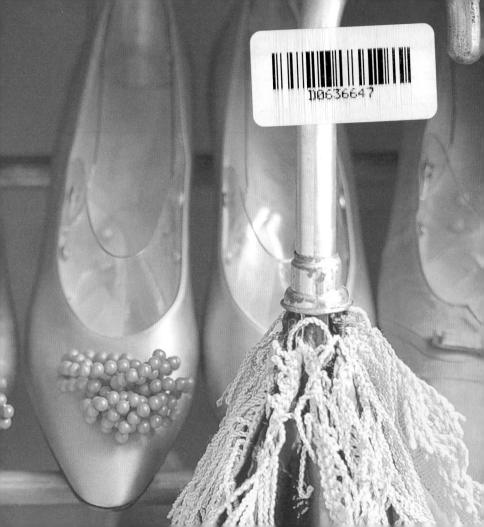

mad about

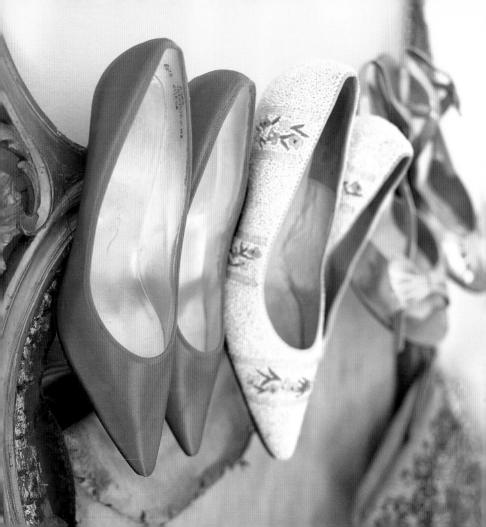

mad about

Shoes

Emma Bowd

RYLAND PETERS & SMALL

LONDON NEW YORK

To Mum.

Designer Luis Peral-Aranda Editor Miriam Hyslop Location Research Manager Kate Brunt Production Patricia Harrington Art Director Gabriella Le Grazie Publishing Director Alison Starling

First published in the United States in 2002 by Ryland Peters & Small, Inc. 519 Broadway 5th Floor New York NY 10012 www.rylandpeters.com

1098765

Library of Congress Cataloging-in-Publication Data

Bowd, Emma. Mad about shoes / Emma Bowd. p. cm. ISBN 1-84172-353-3 1. Shoes. J. Title.

GT2130 .B67 2002 391.4'13--dc21

2002024849

Text © Emma Bowd 2002 Design and photographs © Ryland Peters & Small 2002

The author's moral rights have been asserted. All rights reserved. No part of this publication may be reproduced, stored in a retrieval system, or transmitted in any form or by any means, electronic, mechanical, photocopying, or otherwise, without the prior permission of the publisher.

Printed and bound in China.

contents

Introduction	G	The Temple	36
First Shoes	8	The Party Shoe	42
Best Foot Forward	14	The Perfect Match	46
The Thrill of the Chase	20	The Vacation Shoe	50
Skyscraper Spikes	26	The Wedding Shoe	56
The Favorite Shoe	20	Suppliers & Stockists	62
		Credits & Acknowledgments	64

Shoes make a lot of women happy. In fact, we love them. They are our faithful friends that travel life's many winding roads with us each day. Just to be able to glance down and marvel at their sheer beauty lifts our spirits, irrespective of the many obstacles in our way.

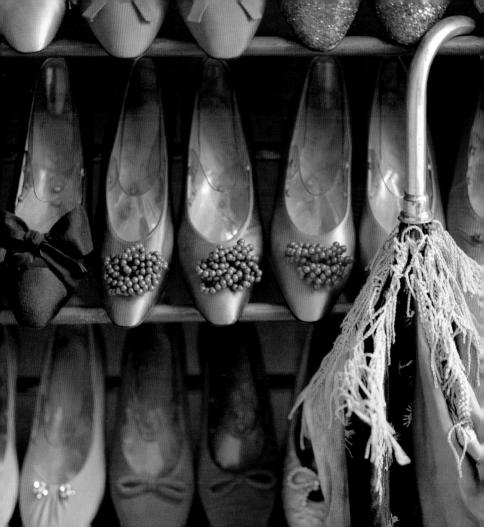

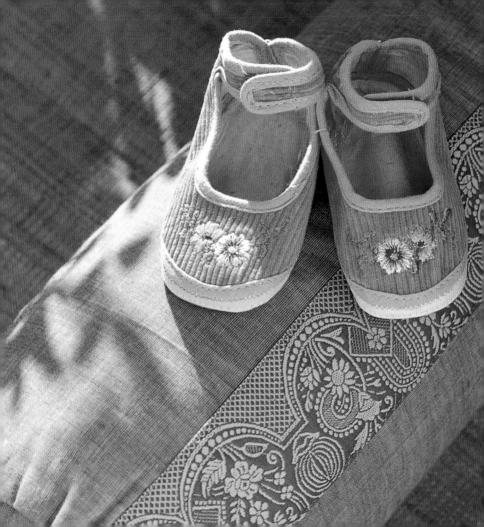

first shoes

ur love affair with shoes often takes hold at a very, very young age. Most people cannot resist buying pretty little pairs of shoes for newborn baby girls, despite the fact that they cannot walk yet, and a pair of socks or booties would suffice-at a fraction of the cost. These shoes will usually not fit well and serve no real purpose in life at all, except to sit on a shelf and look absolutely gorgeous in all their flowery and butterfly-embroidered glory. Sound familiar? We are products of our environment, after all! By the time of toddlerhood, the seeds of the romance are often fully sown, ready to blossom into a lifetime of shoe-wearing bliss.

5 first shoes

Like every little girl before us with a love of pretty shoes, we go on to appreciate the subtle nuances of these most marvelous of inventions. It will soon become gloriously clear that a pair of designer high heels equates with instant glamour; that sandals

a fine romance

symbolize happy carefree summers; that brightly colored shoes cheer up even the dreariest days; and that slippers have magical powers capable of making the worries of the world simply melt away. Shoes are truly the foundations of a lifetime's happy, fond memories.

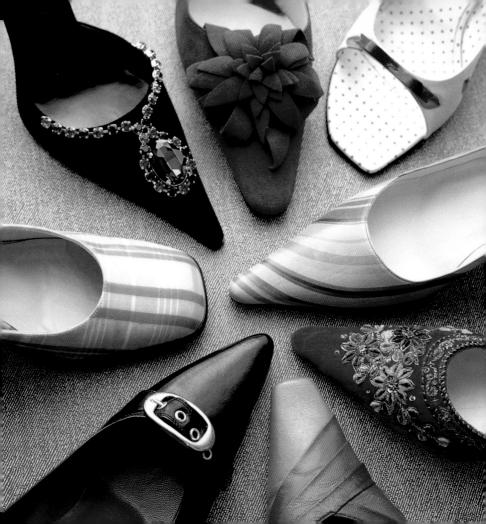

best foot forward

he avid female shoe connoisseur is absolutely convinced of her prowess when it comes to assessing the personality of a stranger at fifty paces-or however close she needs to be to see their shoes! We've come a long way from the days of tying a bit of leather and vine around our feet in the dim light of the cave. The styles of shoes we choose to wear speak a thousand words about how we wish the world to perceive us. Kitten heels, spiky stilettos, toe-crunching mules, platform wedges, chunky clogs, twotoned brogues, satin logo-encrusted slippers, leopard-print loafers, strappy sequined sandals, fake leather, patent leather, natural leather, purple leather

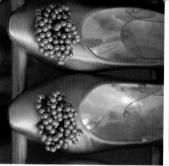

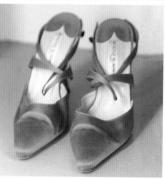

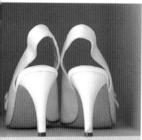

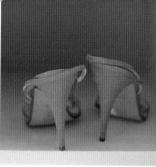

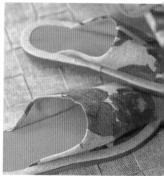

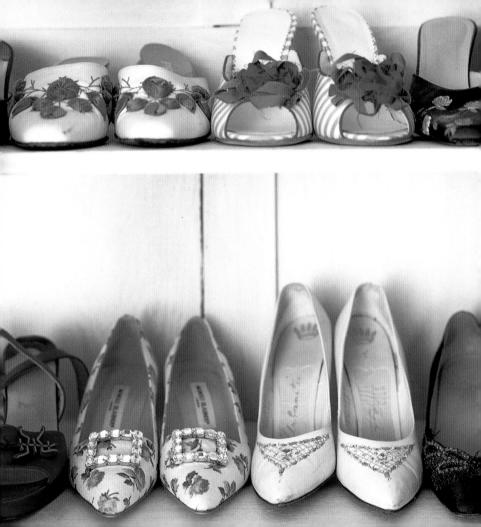

-they all give away vital clues about the person within. And nowhere do we use the skill of putting our best foot forward more effectively than in the all-important job interview. Here, you will invariably present yourself in your best pair of shoes. Not too high,

well-heeled

not too low, perfectly matching your outfit, polished, fashionable and understated, reliable and sophisticated. Everything you want your prospective new boss to know about you without actually having to say a single word! Your choice of shoe can speak volumes.

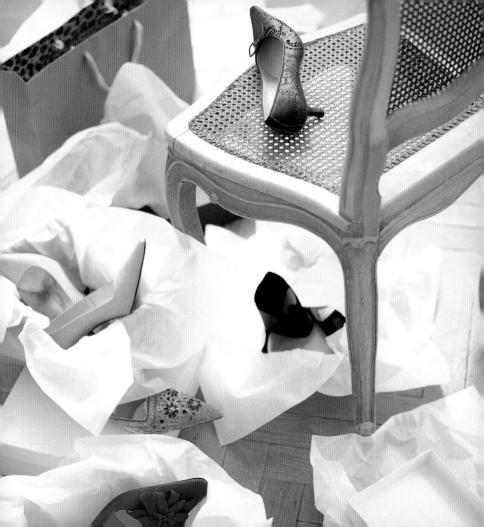

the thrill of the chase

an there be a more enjoyable way for the shoe-lover to spend a \prime Saturday morning than experiencing the adrenaline rush of a shoe sale? Better still, not simply any old shoe sale, but the phenomenal "designer" shoe sale. In this situation one of two moods will envelop you. First, there is the "sensible" mood, whereby you purchase the comfortable and classic pump, which you will wear forever, and could not have afforded to buy had it not been on sale at a reduced price. Alternately, there is the ridiculous "I-can't-possibly-leave-thisstore-until-I-have-bought-something" mood. It is in this frame of mind that you will find yourself using part of

d the thrill of the chase

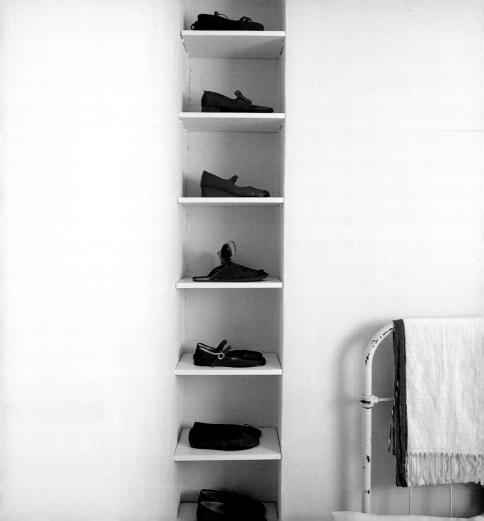

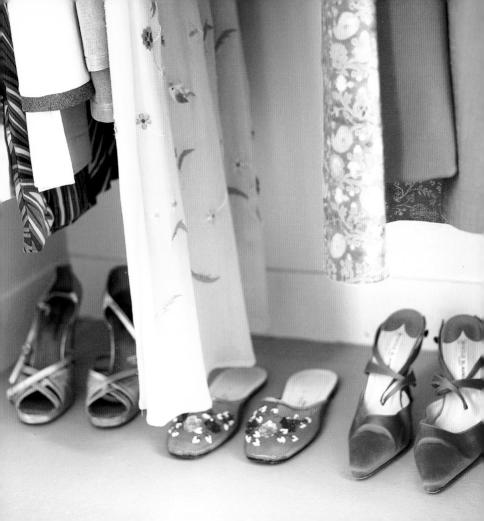

next month's grocery money for a new pair of shoes. A gorgeous pair of green satin Jimmy Choo mules, for example, with a frighteningly high heel (that you have no chance of ever being able to walk in without applying superglue to the soles of your feet)

moments of madness

that are a size too small and don't match a single outfit in your wardrobe. It doesn't matter—they were half price, and they are Jimmy Choos, for goodness sake. The thrill of the chase can provoke moments of madness in even the most rational of women!

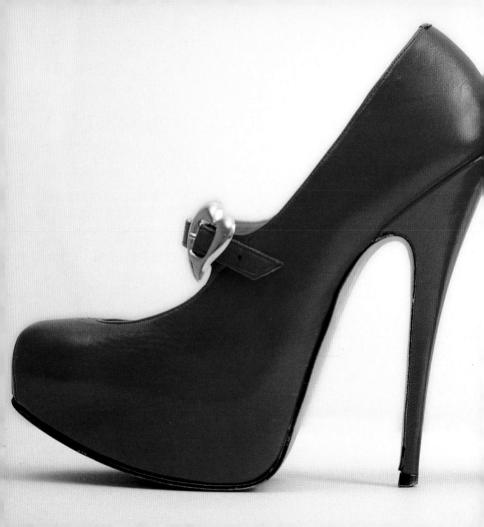

skyscraper spikes

ther than the female human, no mammal on earth would consider maiming and torturing themselves in an effort to gain an extra three inches of height. But as any woman knows, the rewards of high heels far outweigh the costs. Height is desirable. Height is power. Throughout history, what red-blooded male has ever been able to resist the alluring, magnetic pull of the female form gently swaying and swirling its way past him on mile-high stilettos in a little black dress? From the moment you slip on your sassy, razor-sharp Manolos, the world is truly your oyster. Well, almost—as long as you avoid parquet floors and grass lawns!

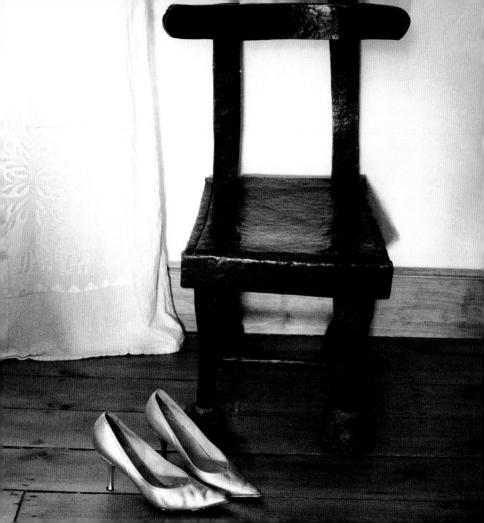

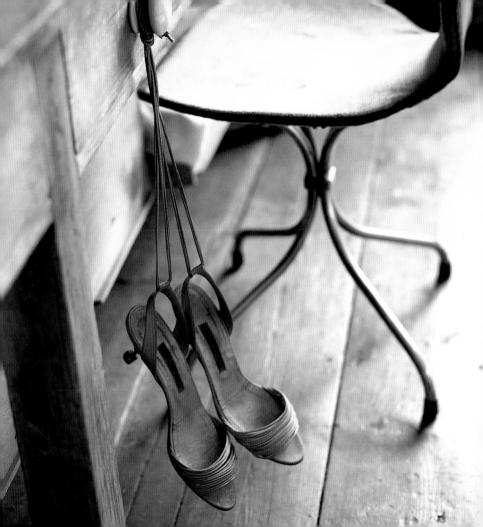

the favorite shoe

n the eyes of the shoe lover, the "all-time-favorite shoe" is the pair of shoes you just can't throw out, because you hope in your heart of hearts that two-tone sailor shoes will come back into fashion one day. Or, they are the shoes that you wished you had bought two pairs of because you've already had them resoled three times and it is just not possible to milk one more season out of them. Conversely, a seasonal favorite can be a pair of shoes that you buy at the beginning of the summer and wear every single time you leave the house. Irrespective of whether they match your outfit. You just love them. Even though you've got 20 other pairs of

a the favorite shoe

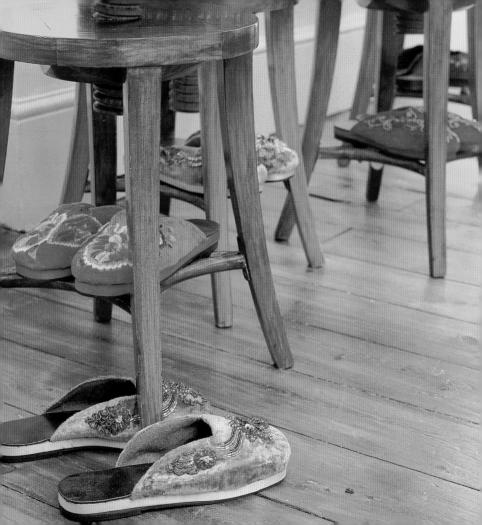

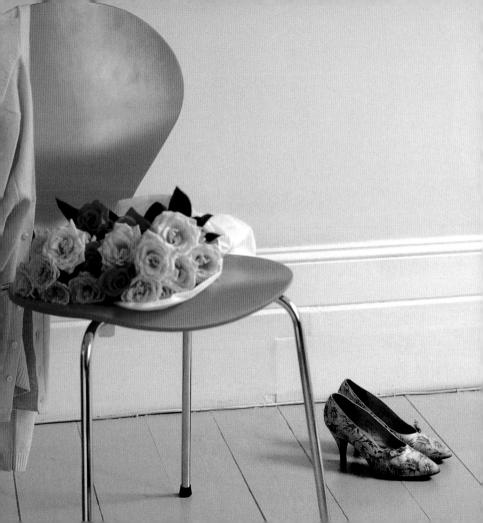

shoes you could choose from—as your partner will undoubtedly point out. These types of shoes usually die a quick and painless death through general wear and tear. And just as well, because they date very fast and are completely passé by next summer.

loved to bits

Another version of the seasonal favorite is when you find the most amazing pair of shoes that are so comfortable and versatile, that you have to buy them in five colors so you can wear them to work every day, with as many outfits as you possibly can.

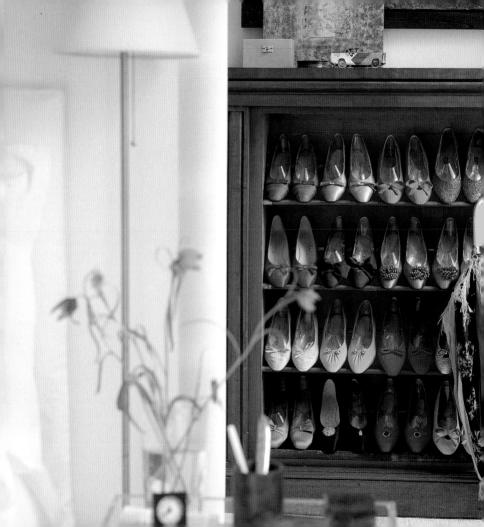

the temple

he genuine shoe lover has a bulging collection of shoes that vary in color, shape, material, price, and height. And there is no greater measure of your devotion to your shoes than the way you care for and store them. Do you lovingly wax and polish and resole your shoes before they start to wear little holes that you can suddenly feel the pavement through? Or would the state of your shoes be more accurately described as shabby and well loved at best? Or are your shoes thrown into the bottom of your closet to form a mangled heap like Mount Vesuvius following an eruption? Did you remortgage your house and sell your

o the temple

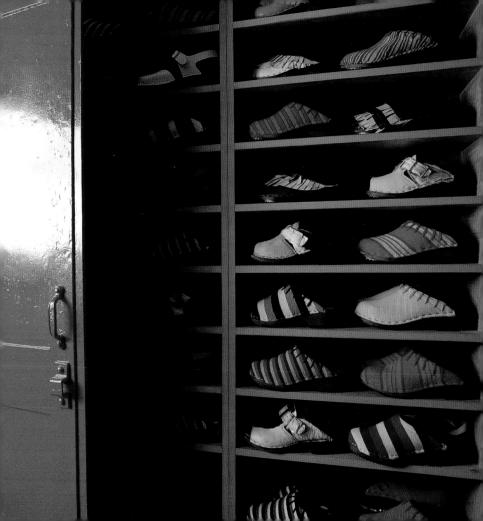

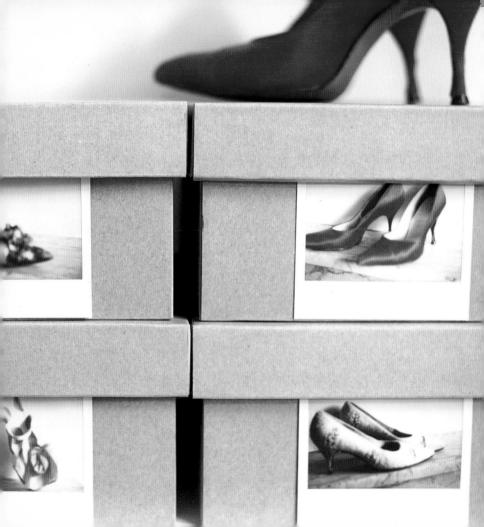

car so you could afford to buy one of those trendy, super-organized built-in units, where every pair of shoes has its own special little dedicated shelf or drawer? The truly devoted among us, however, will always ask to keep the shoeboxes and paste small photo-

shoe princess

graphs on the outside of the box just to remind us of its contents once neatly packed away in our closets. If hiding your beautiful bounty behind closed doors is not your style, then don't hesitate to enjoy their company with fabulous open display storage.

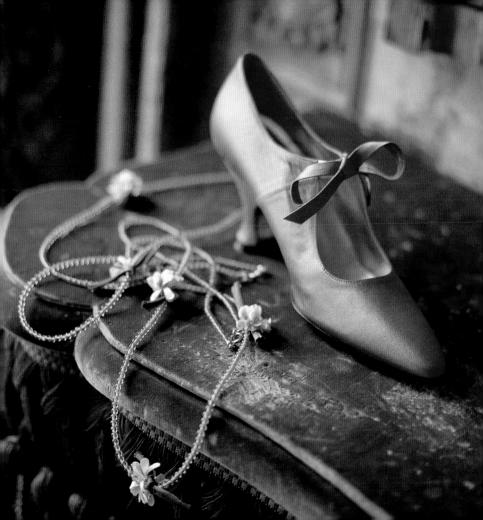

the party shoe

f ever an excuse is needed to buy a new pair of shoes, surely a party is the ultimate one! It is the perfect opportunity to sideline those sensible work shoes and be carried away by the frivolity of the occasion. Designers delight in luring us with dizzying arrays of divine party shoes in delicate fabrics, trimmed with rhinestone butterflies, exquisite glass beads, faux pearls, and sparkling sequins. The goal of any party shoe is, of course, glamour. At all costs. It doesn't matter if you cannot walk more than five steps at a time in your rhinestone-bejeweled stilts without a little rest to regain your balance and your composure. Find a spot, stand there, and look good.

★ | the party shoe

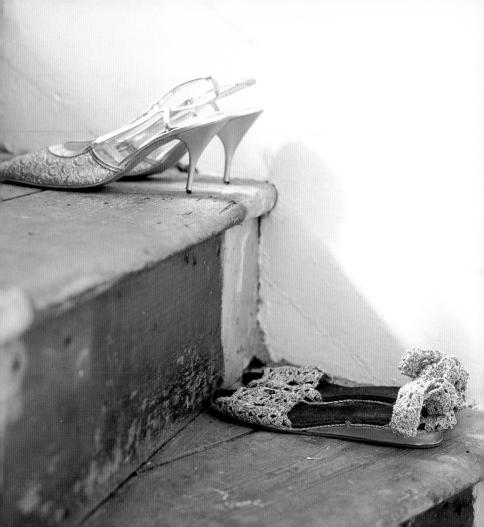

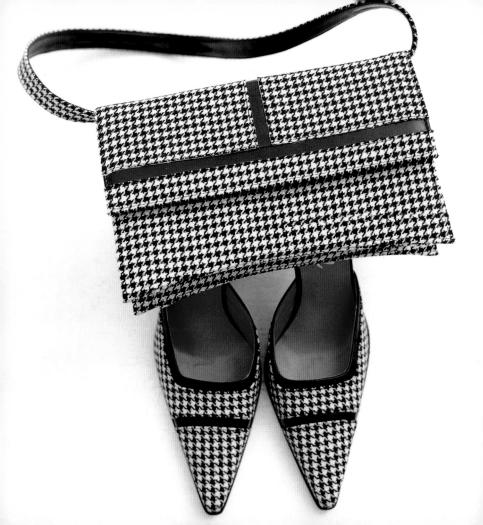

the perfect match

he following four small words are guaranteed to bring happiness to the heart of any die hard shoelover ... "matching shoes and handbag." There is something truly pleasing and unquantifiable about the look and feel of the identically colored, stitched, or beaded material in all its glory both on your feet and over your shoulder. The contribution that the matching shoes and handbag make to the transformation of a woman's whole ensemble is far greater than the sum of the parts on their own. The perfect marriage of shoes and handbag could catapault you to "accessory nirvana," making you stand out from the crowd as the ultimate statement in style.

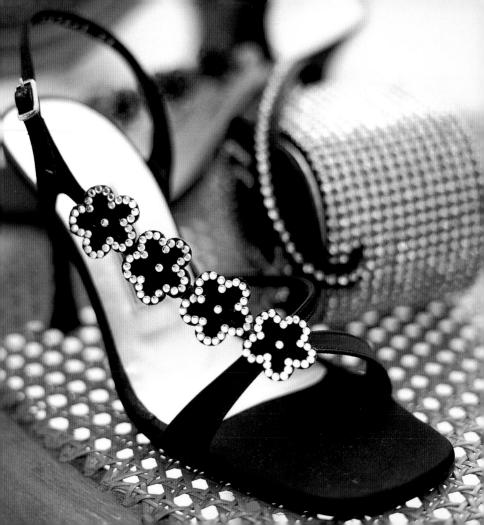

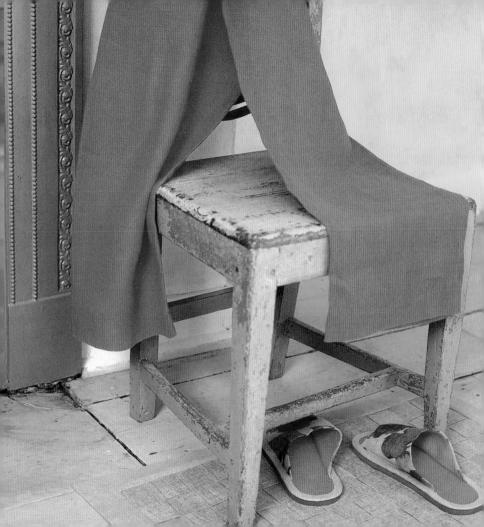

the vacation shoe

hy is it that we manage to pack the same number of shoes (a lot) for a weekend break to New Orleans as we do for a week in New York? It's quite simple really-it's a girl thing. We cannot survive happily with just one or two pairs of shoes like our male counterparts. Different shoes go with different outfits. It is best to be prepared for all foreseeable weather changes and social activities throughout the period of absence. End of story. A summer vacation is not a summer vacation without a pretty pair of sandals and painted toenails to match. A sign of a truly great vacation is the purchase of a unique pair of shoes that will

3 the vacation shoe

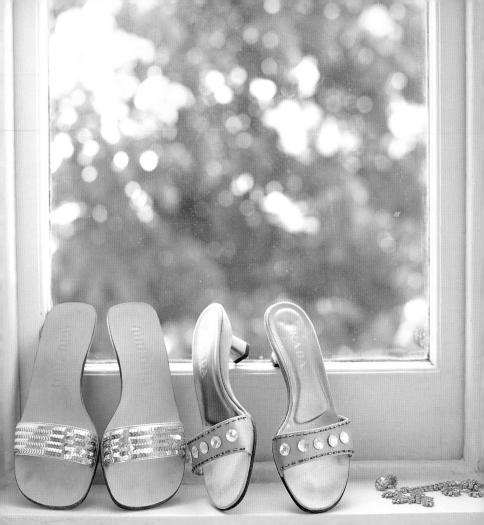

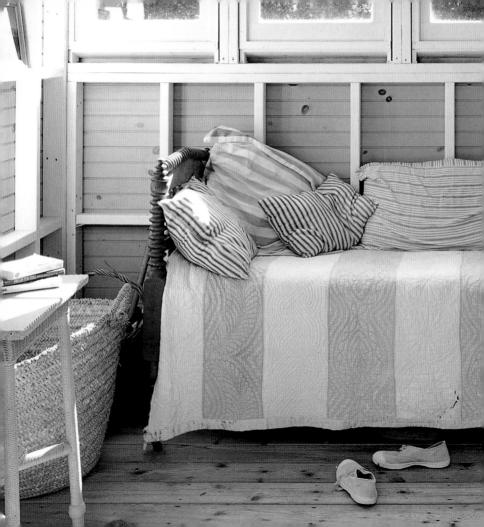

forever remind you of happy times spent away. All you have to do is slip into your striped silk slippers, and you are quickly transported back to a special place. The sights, the sounds and the smells of that intoxicating Turkish bazaar, for example, where you once spent hours haggling over the price of a rug, while sipping what seemed like endless cups of fragrant tea.

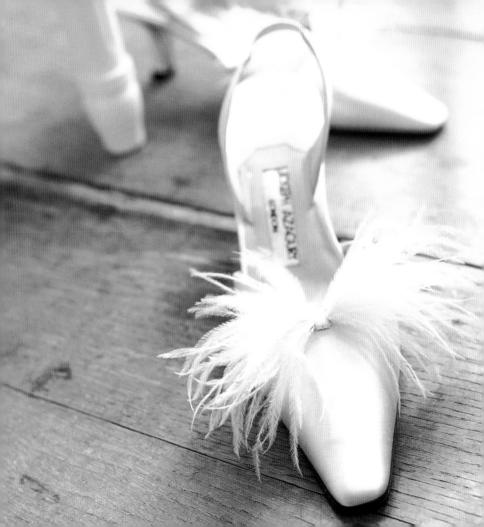

the wedding shoe

hat better way to start your married life than as you mean to continue? Commissioning a pair of made-to-order shoes covered in the material of your wedding gown, which will make you glide down the aisle feeling every bit the princess that you are. For the total effect, you will of course have a divine little handbag made and covered in the same fabric, too. The sheer luxury and indulgence is more than compensated for by the instant creation of your very first set of family heirlooms! To complete the theme, why not give your bridesmaids satin-covered evening shoes and handbags to match their dresses, as a very personal thank-you

s the wedding shoe

gift that you know they will be able to wear and enjoy after the big day? Wedding shoes, by their very nature, are extra-ordinary shoes that need scrupulous planning—at least as much time as that given to your gown. Sexy sling-backs may look appealing in

dress to impress

their brilliant white and feathered haze, but churches and reception venues may have mountains of awkward steps and slippery slopes to negotiate. Choose your shoes wisely, and be sure to pencil in plenty of walking practice to guarantee that picture-perfect day!

suppliers & stockists

Anthropologie 85 South 5th Avenue New York t. 800 543 1039 for stores www.anthropologie.com

Barneys New York 660 Madison Avenue New York NY 10019 t. 212 826 8900 www.barneys.com

Bergdorf Goodman 754 5th Avenue New York NY 10019 t. 212 753 7300 Bloomingdale's 1000 Third Avenue New York NY 10022 www.bloomingdales.com

Chanel 15 East 57th Street New York NY 10022 t. 800 550 0005 for stores www.chanel.com

Coach t. 800 444 3611 for stores www.coach.com

Emma Hope 53 Sloane Square London SW1X 8AX England t. +44 (0)20 7259 9566 t. +44 (0)20 7792 7800 for stores www.emmahope.co.uk

Gucci 685 Fifth Avenue New York NY 10022 t. 212 826 2600 www.gucci.com

Jesus Lopez 69 Marylebone High Street London W1U 5JJ England t. +44 (0)20 7486 7870 Jimmy Choo Olympic Tower 645 Fifth Avenue New York NY 10022 t. 212 593 0800 www.jimmychoo.com Kate Spade

454 Broome Street New York NY 10012 t. 212 274 1991 www.katespade.com

Macy's 151 West 34th Street New York NY 10001–2101 t 212 695 4400

www.macys.com

Manolo Blahnik 31 West 54th Street New York NY 10019 t. 212 582 1583

Neiman Marcus t. 800 365 7989 for stores www.neimanmarcus.com

Parallel 22 Marylebone High Street London W1M 3PE England t. +44 (0)20 7224 0441

Prada t. 888 977 1900 for stores Saks Fifth Avenue 611 Fifth Avenue New York NY 10022 t. 212 753 4000 www.saksfifthavenue.com

Sergio Rossi 835 Madison Avenue New York NY 10021 t. 212 396 4814 www.sergiorossi.com

Vivienne Westwood 71 Green Street New York NY 10012 t. 212 334 1500 www.viviennewestwood.com

credits & acknowledgments

key: a=above, b=below, l=left, r=right, c=center

Special photography, front and back jacket: Chris Everard Other photography by:

Chris Drake: *8*; 54 Chris Everard: *4-5*; *11*; *14*; *17 br*; *20*; *26*; *42*; *46*; *49* Catherine Gratwicke: *17 bc*; *18* Lulu Guiness's house in London; *23* Laura Stoddart's apartment in London; *29*; *33* VV Rouleaux, Ribbons, Trimmings, and Braids; *39* Designer Ann-Louise Roswald's apartment in London; *53* Debi Treloar: *11*; *12* Verity Welstead: *34* Lulu Guiness's house in London Andrew Wood: *7*; *17 al*; *17 ac*; *17 bl*; *17 ar*; *36*; *endpapers* Polly Wreford: *2*; *17 lc*; *17 cc*; *17 cr*; *24*; *30*; *40*; *45*; *50*; *59*; *60*

Thank you to the entire team at RPS for making a small but lovely dream come true. Special thanks to Annabel for taking me seriously in the first place; Alison and Miriam for their support and guidance; and Gabriella, Luis, and Kate for the gorgeous images. And a million hugs to Darcey without whom this book would never have happened.

The author and publisher would also like to thank everyone who made the photography for this book possible. Grateful thanks to Emma Hope; Emma Hope for Paul Smith; Jesus Lopez, and Parallel for allowing us to photograph their beautiful shoes. Special thanks to Debbie, Patricia, Susan, and Julia.